ADVANCED PRAISE

"Franceska Alexander's book, *Gallery Ready* is heartfelt—generous—clear and practical. I believe for many it will be a valuable tool in helping to ease the anxiety for artists stepping into the mysterious world of galleries and professional practices—well done!"

Michael David, Artist & Gallery Owner,
Schweitzer & David Contemporary, New York

"Franceska Alexander's book, *Gallery Ready,* about getting into galleries is a handy, concise reference guide for all of the steps that artists need to take. I literally have this question every single day from the artists I work with, so I'll be referring them to Franceska's guide as a place to get them started."

Cory Huff, Author & Coach,
*How to Sell Your Art Online: Live a Successful
Creative Life on Your Own Terms*

GALLERY READY

A CREATIVE BLUEPRINT FOR VISUAL ARTISTS

FRANCESKA ALEXANDER

NEW YORK

LONDON • NASHVILLE • MELBOURNE • VANCOUVER

GALLERY READY

Published in New York, New York, by Morgan James Publishing in partnership with Difference Press.
www.MorganJamesPublishing.com

The Morgan James Speakers Group can bring authors to your live event. For more information or to book an event visit The Morgan James Speakers Group at
www.TheMorganJamesSpeakersGroup.com.

ISBN 978-1-68350-797-0 paperback
ISBN 978-1-68350-798-7 eBook
Library of Congress Control Number: 2017915895

Cover & Interior Design by:
Megan Whitney Dillon
Creative Ninja Designs
megan@creativeninjadesigns.com

In an effort to support local communities, raise awareness and funds, Morgan James Publishing donates a percentage of all book sales for the life of each book to Habitat for Humanity Peninsula and Greater Williamsburg.

Get involved today! Visit
www.MorganJamesBuilds.com

I want to do to you what spring does
with the cherry trees.
PABLO NERUDA

I dedicate this book to visual artists
who desire their art to be gallery ready.

CONTENT

INTRODUCTION

"An artist cannot fail; it is a success to be one."

CHARLES HORTON COOLEY
AMERICAN SOCIOLOGIST

When someone enters my gallery, they will often hear, "Welcome to The Gallery!" It feels appropriate to do the same here in this introduction, but instead of welcoming you to the gallery I will welcome you to this book.

This book is for you the artist, to help you understand the behind the scenes of a working gallery and the steps you can take to increase your chances of showing your work in the gallery of your choice. Generally, on any given day, among the many visitors that do come into the gallery, there are also artist's hoping to meet the person who may fulfill their desire to show and sell their artwork. I know how challenging and mysterious it can be for emerging artists to get their art into a gallery or even book a show inside a café or business location. Trying to

figure out the process, to know what the protocol is, who to talk to and how to get their attention to see your art, can cause stress and ultimately prevent some of you from even trying to move forward with your artistic longings.

I still consider myself an emerging visual artist, as well as a seasoned veteran gallery curator, manager and owner. I own a gallery that receives between up to 10 submissions a week, and sometimes I can receive this many requests & reviews of art in a given day. My experience and observations of best practices are fine-tuned yet flexible and I want to share with you what works best for the artist, for the gallery owner, director, and gallery staff.

An artist who is represented in a gallery enjoys the benefits of having their work seen often, knowing the visitor response, and hopefully being discovered by a collector. They also receive valuable support from the gallery. Galleries play a vital role in communities at the regional, national and international level.

To show art at a gallery now more than ever requires a partnership model. This is where the artist and the gallery find beneficial ways to work together. The gallery is a business and for it to survive it has to be successful not only showing but ultimately selling art. I believe without a partnership model it struggles to be a total success. This seems to be a fairly new evolution for artists to consider when deciding where to put their art in a brick and mortar gallery. Partnership is generally thought of in a cooperative gallery model. Those types of collective venues show many artists together, often unrelated. It

is usually based upon artist's who are willing to show up at the gallery, take time out of their studio and be on a regular schedule to sell art. A new partnership model at a gallery encourages the artist to be comfortable enough to visit the gallery they show in which supports the selling of their artwork on many levels.

Gallery operations have changed significantly since we first opened the gallery I own in 2004. This continues to evolve and change each year. From 2004-2008, the majority of our artists had little contact to no contact with the gallery. Their art was shown and their consignment checks were sent within 30 days after the artwork had sold. Art openings happened monthly with large local and regional attendance, in addition to sold out shows. On the night of the openings we also had Art Talks with artists from around the country. When our large art show events ceased to bring sales and turned into expensive, well-attended local parties we began to significantly tone down our event schedule. We became quite modest in our creative efforts to generate events and sales outside our native area.

In 2014, when I became the sole proprietor of my current gallery, I realized that something was amiss in the general business model we had become accustomed too. We still had a very beautiful art presence in our local area, but not enough interest in original art to generate substantial art sales. It wasn't that the gallery lacked a public attendance because the average visitor still spends upwards of 45 minutes looking at the art in the gallery. It just was obvious that current operating systems needed to change if the gallery (and I) were to survive the coming years.

Many of the original artists were inherited into the current gallery from the old model setup years ago. These were talented career artists I encouraged to continue in a new setup of more participation. As it turned out, some were at the age of retirement anyway, some unfortunately had passed away, and many were now selling online directly to the collector. However, over time, I have encouraged the new artists to this gallery, to become more aware of why and how "their" gallery serves them and vice versa.

As artists and gallery owners work together, the true value of the storefront gallery will remain viable and hopefully profitable, making regional fine art markets able to serve the larger community of collectors, artists, general visitors, as well as the gallery itself.

CHAPTER 1
A Gallery Owner is Born

"It does not matter how slowly you go, as long as you do not stop."

CONFUCIUS
CHINESE PHILOSOPHER

I was lucky enough to receive my fine art eye, and aesthetic discernment from my father, a San Francisco Bay Area art collector. He was also figurative sculptor and journalist photographer. Our new 1950's home was a part of the boon of suburbia. Our art collection filled our modest home with original large-scale nude oil paintings, modern stone sculptures and lots of musical instruments. My mother was a woman with a flair for fashion and interior design. Our home interior was more like an art gallery, entirely painted chalk white, including the brick fireplace I never remember a fire in. This home stimulated my thoughts, imagination and creativity. Even though it was a bit stark for a warm family environment, my life

there was enamored by hours of gazing at brush strokes on the many original paintings hanging on the walls of our home. This included a particularly famous painting of a naked boy with a horse painted by Picasso. A voracious thirst for learning about painters grew within me and I read biographies of famous artists such as Renoir, Rembrandt and Picasso from a very young age.

Sadly at the ripe age of 7 years old, I was convinced you had to have come out of the womb with a paintbrush to be an artist. This bogus idea was partly because as a girl there were so few women artists' voices in art history, as the majority of artists were men. It never ceased my enthusiasm for art and kept my appreciation steady. A desire to create my own artwork, though initially fraught with challenging old beliefs, eventually matched my inherent talents to make better art with skill and confidence.

Over the course of my life, I have worked with hundreds of artists; assisting many emerging artists, as well as established artists, to organize, guide, support and sell their art in the gallery. In addition, I have helped hundreds of customers in their inquiries, acquisitions, custom designs, deliveries, special displays and making contacts for commissioned art with the artists they have discovered at the gallery. I have managed to keep this gallery alive through changing cycles of discretionary spending and the sometimes-bleak years of unknown futures and downward economic shifts.

As creatives, we can appreciate the upward financial cycles that allow people to purchase art for the emotional value and the contribution art brings into a home or office. I attribute

my dedication to this aesthetic purpose and my belief in the importance of having a public place to view and purchase fine art. This serves the community in ways that is oftentimes only felt. I am grateful my intuitive faculties have been high enough to navigate a curious business model with a critical eye and so far keep this savvy brick and mortar art gallery open.

It's All In The Timing

Hundreds of artist submissions have flown across my desk for the last 14 years. Since the submissions for the gallery have been incessant from the start, it has also been a bit of a burden--though in a good way! This is because of the time it can take to vet and respond to artists in a respectable and timely fashion. There are so many of artists vying for a spot in this magnificent art space it has become increasingly challenging to communicate how art is chosen, and what will and will not work for all concerned: gallery, customer, and artist.

My gallery is an elegant environment that was created by an architect, a sculptor, a designer and artists. I must say anything displayed on the walls here looks great, from the most radical art to the finely articulated, figurative, impressionist or whimsical art. Located within an 1850's building, the museum-like environment enhances and validates the value of the art piece being viewed. Ultimately, through skill, taste, and aesthetic presentation it all comes together in a unique collection of artists. Jewelers, ceramicists, painters, photographers, printmakers,

sculptors, and more, find this gallery model and location very desirable for their art. For years, and with the thousands of artists and visitors I have worked with during this long creative sojourn, it continues to serve the art appreciating public in the tiny town of Nevada City.

When the gallery first opened, there were piles of envelopes with slides and portfolios for us to review. We thought we would be able to decide together as a "juried group" which artists to choose to show. But the immense amount of work that arrived was mounting faster than we could review in a timely manner. When CDs came out the volume increased, and hundreds stacked for further review. We considerately composed a kind letter of rejection on our letterhead emphasizing the need to continue the creative passion and infused with kindness to the hopeful artist inquiries. However, over time, artist submissions were just more then we could comfortably handle judiciously. Once in a while an artist became upset with the lack of response to their gallery submission--and no doubt many other galleries as well. I think it is fair to say; there may be a lack of understanding as to what it takes to keep a gallery viable given the multitude of submissions a gallery may receive. Now as artists are selling online it has created a new way to circumvent working with gallery frustration. Online artist websites have added additional woes to the gallery business model. Competition for the exclusive sale and understanding where to draw the line with an artist showing in a gallery and also selling online adds stress to ultimately whose sale is it, the artist or the gallery or both?

There is no doubt that most visual artist's have the aspiration to be seen in a gallery. When they see their artwork as a perfect fit, it can often surprise me, "My art would be perfect in this gallery!" and I take a peek and see their perspective? I love helping new artists sense their next move to make that happen, and if we have the time to meet, I ask the questions and get to their immediate needs. My best case scenario is working with artists to get them gallery ready, and to do that, it's making the inquiring artist my top priority. I do take the gallery and the artists seriously. This is why I want to help show you in this book what you can to do as an artist to stand out from the crowd be effective with your time and with the time of gallery to make your art successful. This book is geared towards answering the many questions I've answered over the years, and to guide you towards being gallery ready. It is my intention to prepare you with what is needed to create unique art pieces that allow you as an artist to make an impact on the right gallery for you and to your art collectors for years to come.

The Artist Then and Now

"The job of the artist is always to deepen the mystery."

FRANCIS BACON,
IRISH ARTIST

Rarely has the artist's path ever been easy. A "working artist" or "career artist" works hard to be seen, and history has generally ignored living visual artists, celebrating them only after they pass on from this realm. This historical evidence does seem to

be changing now with online technology and the visual arts. It seems to be actually easier for an artist to be seen around the world through websites that show and sell her art. It takes virtual tools and networking abilities but today they open up doors right at her fingertips. The mystique of an artist is now about branding and with the benefit of the World Wide Web, there is also, tremendous competition. However, selling through an art gallery will take a certain level of professional mastery and planning.

Good, Bad or Meaningful Art

"A work of art which did not begin in emotion is not art."

Paul Cezanne,
French Artist

What is good art, what is bad art, and what is meaningful art? When is art good enough for an art gallery and what does it take to make a piece of art gallery ready? If you are a visual artist and you are passionate about showing your work then read on to see what you may need as an artist to be gallery ready.

For the most part, art is very subjective. How does an artist turn plain canvas and paint into a piece of fine art or a sculptor cast his creation out of a lump of clay into a near priceless Objet D'art? Is it an entirely subjective experience, or can there be an inherent value occurring in the mysterious making of art? In this book I will attempt to answer with my experience and ponderings about art through my life as an artist and gallery owner.

CHAPTER 2
The Gallery Legacy

"Let the beauty you love be what you do."

RUMI
13TH CENTURY SUFI POET

H ow I came to own my current gallery actually began in 2002, when I met my future companion and dearest friend, John Mowen. John was a stone sculptor and bronze artist. He made his living making art for over thirty years. He was salt of the earth, a hard working artist with an expert skill in his craft/art making. He traveled throughout the United States showing and selling his art at the finest art shows. It takes a lot of effort to get into the quality art shows around the United States and since 2008 the better shows were in the Midwest and on the East Coast. This becomes a challenging dilemma of transportation expenses when you reside in Northern California as John did.

Coast to Coast Art Shows

During the eighties and up until the last ten years or so, arts and crafts shows, if you were a quality artist, required filling out applications manually with specific details from show to show. Application presentation was judged almost as much as the art itself. It would also require professional photos from a studio photographer who would make the images into slides. This meant finding a photographer who specialized in studio art photos and understood the best lighting for art in a photograph; transporting your artwork to the photographer, and getting everything up to date as you grew as an artist. Filling out the application specifics could be very stressful for an art show booth. It required great concentration because the forms were complicated and oftentimes artists such as John, asked family or friends to fill out his forms to make sure they were legible, accurate and made the very strict postal deadlines. The shows also required an application fee, some non-refundable. The "wait and see" time period to see if you were accepted into the art show put your planning the year ahead generally on hold, until you heard if you were accepted into the show or not. If so, you hoped to land a great booth location on the show floor plan and that you were *not* put on the "we will let you know at the last minute waitlist". Today there are data programs like Zapplication, that have automated most of the tedious work required in years past for art shows. The application is sent directly to art shows with a push of a button on your computer!

Being an artist on the art show circuit, did, and still does, take a tremendous amount of stamina, street smarts, frugality, risk and expense. Many outdoor art venues are experienced strictly as entertainment. However, due to the historically high attendance on those art-focused weekends across the country, it can often be quite profitable for an artist. The shows create seasonal villages of gathered artists who also become good friends through the years. If the show is a good one, that is profitable, it also offers the possibility of earning thousands of dollars over the weekend. Multiply that with 6 to 30 shows a year, and you have a creative cash flow, making art and selling it. The individual artist determines whether a show is worth doing because in the long run, the art show life can be quite taxing the healthiest of artists.

Mowen Sculpture Gallery

When I met John, we instantly connected in the realms of love and business. He complained often of being "on the road". When I noticed how hard he was working from long weekend shows strung together by highways traversing the art show circuits, it was easy to imagine showing his work in our town. The quality of his work was earthy and elegant. My intention for his gallery was to help mitigate his "road weariness" when he returned home. I felt a local gallery for his art would serve him well. Within our first few weeks of meeting, I offered a fine art gallery space for his sculptures in my downtown business location. It turned out to be a perfect fit for us. His art encompassed contemplative

scriptures and sacred sculptural forms in stone and limited edition bronzes. We added Tibetan Thangkas, Asian artifacts, music and wisdom books to round off a sanctuary environment filled with the sensibility of contemplative art. This humble sculpture gallery became a place for John's art establishing a growing community of collectors.

Mowen Solinsky Gallery

About one year later, a very large retail space, perhaps one of the largest in our little town of Nevada City quickly came up for rent. A 40-year veteran retailer was retiring and was one of only two prior tenants had graced that space in the past 50 years. With 24-foot high ceilings, it was quite ample for John's 14-foot high bronze sculptures. However, we were actually on our way to the other side of the world, to visit Myanmar for an epic month long adventure.

John's longtime friend and art photographer, Steve Solinsky, partnered in this creative idea, and the four of us, including Steve's wife, Susan, decided to turn the dated cavernous space into a high-end pro-artist gallery. These dedicated artists put their last names together, pooled their resources and named the gallery the Mowen Solinsky Gallery. I became a working partner and handled the behind the scenes systems including the bookkeeping and on the floor management. We shared in the design of the interior, and many people from our community worked together to gut the interior and create a new space. We

poured our hearts and souls into a stunning local jewel glistening with beauty in the heart of the downtown historical district. The Mayor even declared it "Gallery Day in Nevada City," May 8, 2004. Attendance was in the hundreds with friends and family coming from afar for our festive opening night celebrating fine art in Nevada County.

The gallery had steady art sales for those first four years. It was then, John and I decided to carve out our next adventurous month long trip trekking to the summit of Mount Kailash in the Himalayas of Tibet. We went with a twenty-two-member Vipaasana meditation group and became the first foreigners to enter the closed borders of China/Tibet following the 2008 Summer Olympic Games in China. We were unaware of the severe economic nosedive occurring in the United States at the tail end of our sacred journey. When we arrived back home in Nevada City, one month later, the dire financial impact showed immediately upon gallery sales. Steve and John were now dipping into their personal funds to keep the gallery afloat. We had already committed to our fourth booth attendance at the prestigious SOFA (Sculptural Objects and Functional Art) Show at the Chicago Navy Pier held each year the first weekend in November. SOFA is a premier show for galleries exhibiting some of the finest artists in the states and around the world.

The expense of a gallery traveling to an art show across the country is multiplied tenfold to that of solo artists, but we really couldn't back out of our financial commitment, we were

just going to have to do show up and do the show. Our booth of hand-selected California artists proved profitable overall, though the undercurrent of uncertainty was present, it actually was not enough to hinder our art sales.

Needless to say, the '08 holiday season in California was somber at the gallery. Right after the first of the year, changes in gallery operations began to occur. We found a way to have our strong loyal customer base invest in the gallery by creating special gallery credit cards that increased the customer purchasing power by 10% if purchased ahead of time, an early version of a crowd funding campaign! It was an inspired action that worked to create a bit of forward revenue to continue the gallery. Most of the employees at that point in time were either let go or worked minimal hours as a "skeleton crew".

In January 2009, Steve had a stroke that had him laid up in the hospital for a long period of time. Thankfully, he has now fully recovered. However, by the end of the year, he made a decision to retire as an owner of Mowen Solinsky Gallery. Steve still continues to photograph, print and sell photographs at the gallery from his massive collection of images. At the time of Steve's gallery ownership departure, along with the financial downturn, John seriously considered calling it quits as well. Being the consummate retailer I encouraged John to continue owning the gallery, posing the question, "Where else would he find a perfect space to show and sell his monumental bronze sculptures, in his hometown within a community he loved and where he and his art were so deeply appreciated?" John was not only good at making art that mattered, his deep conversations about art as

medicine always left friends and visitors to the gallery uplifted. John continued solo ownership of the gallery from 2009 onward, still challenged to create systems that mitigated the low sales volume with the need to stay open for the community because undoubtedly, the sustained emotional value of the gallery for the visiting public is a deeper consideration. Those who venture into our unique town are often surprised by the quality of art made by so many accomplished artists in this gallery.

By 2010, John was now at a financial crossroads, as the gallery wasn't able to give any indication it was the viable business model he had once envisioned. He decided to make a concerted effort to get back on the road with his sculptures and begin the fine art show circuit once again. While on the road, he grew the gallery in a new direction; bringing back extraordinary American artists from his art show tours. These were artists who normally wouldn't consider being in a gallery because they worked the art show business model mentioned earlier, for getting their art out into the world. This increased the gallery's uniqueness as the extraordinary collection of fine artists grew.

Many artists have felt sketchy about consigning their art to a gallery. Galleries can have a bad reputation for many experienced artists. Their reasons include not getting paid in a timely fashion, the closing of a gallery and not getting the art back to the artist, or not getting paid at all when a piece of art sells. John worked hard to build a bridge with artists setting the gallery up as a "pro-artist" gallery from the first day of operations in 2004. He was implying the artists would get paid above everyone else, and thus, our reputation was built on that promise. It was here John's

reputation as a gallery owner increased while traveling across the country. While the economy barely made steps forward economically in the arts, more and more artists were showing a new found eagerness to get into the gallery, and the gallery began to fill up with more and more art as a result.

By now it was 2012. I had returned to school to complete a Masters of Fine Arts in San Francisco, commuting bi-monthly and finally graduating with a dream fulfilled of fine arts degree. I still held rank at the gallery continuing to keep up with my back office duties. Since John and I were doing our own thing and away from the gallery quite a bit, the rotation of art and art events became stagnant. The gallery staff kept up with only what had to be done and anything extra fell by the wayside in terms of events and rotation of art.

"To Everything Turn, Turn, Turn"

PETE SEEGER,
FOLK SINGER

The year following the gallery opening, in 2005, John had a cancer diagnosis. With concerted effort, it took about 2 years to move him from illness back to health. However in late 2013, perhaps under the increased pressures of being back on the road, his warrior spirit cloaked in a "pedal to the metal" personality, seemed to take its toll on his health. To add insult to his physicality, in between the art show seasons, his deep

passion for pilgrimage treks filled his leisure time. With earnest intensity, John took his last journey in France and Spain walking alone on the El Camino De Compestelo. When he returned completely exhausted nearly seventy-five days later, he didn't look or feel well and complained of being "bone tired". Going right to the doctor, lab tests were ordered and the results came in while he was on the east coast at the 2nd of 5 art shows. Within several days I flew out to Nashville Tennessee to meet him and together we drove back to California on what would be his last sojourn across the United States. It was a somber drive because the inevitable was in sight. Within a few short and very painful months, John passed away. The sadness of his death continued for some time, but his legacy remains in the soulful artwork he created and lives on in the art collections belonging to friends, family and collectors. He had cast a long and fruitful net of friendships far and wide around the world and will be remembered for his genuine presence of friendliness, humor, kindness, and depth.

So that brings me into how this substantial gallery became my full responsibility, or how I couldn't bear to see this gallery close on the wake of John Mowens sudden death. John's son wasn't interested in carrying on his father's gallery legacy, as he inherited the gallery quickly without preparation. He immediately began to take steps to close the month following John's death in January 2014.

I just wasn't prepared to say goodbye to the gallery and to John in the same moment. Nor was I wanting do run the gallery alone. Considering the years of shared responsibilities it seemed

pretty ridiculous for me to even consider solo ownership, as I never imagined doing ownership by myself. We had held the many facets of running a successful consignment gallery together, albeit unprofitable, but we kept it open being clever collaborators. I reached out for trusted council and even possible partnerships, but in the end I was balancing my hesitancy with a series of whispers, taps and inner nudges I simply couldn't ignore. The crisis of loss became a potential opportunity for me to grow. I listened, grieved long nights, and eventually began to take the steps necessary to transfer ownership from John's son to me. The spirit of my personal challenge called from something unforeseen within me. The lives the gallery touches in the simplicity of an art experience brings unintended joys and blessings as I look back on the last four years. There is no doubt it has been quite a serious and emotional undertaking as I have experienced the gallery change and grow new wings under my guidance in an environment that continues to bring the beauty of art and people together.

I dedicate this book to those who came before me, especially John Mowen, as his voice may be heard woven within mine on pages I will be sharing with you in this book.

CHAPTER 3
Your Creative Blueprint

"Blueprint: something to serve as a model or provide a program of action or guidance"

As mentioned earlier, nearly every single day someone invariably has entered the gallery inquiring the process it takes to get his or her art or someone's art they know exhibited here. What that says to me is there is a lot of art out in the world created from artists who wish to at the least show their artwork, and at the most, make a living selling their artwork. This also necessitates the value of a gallery for showing art to be experienced by the general public.

With all of your initial excitement, upon first meeting a gallery owner or curator, or an employee, please consider your timing and their time when asking what the best protocol is for submitting your art into a gallery. You will end up on the

right foot from the start if you choose to go through the level of protocol that works for each gallery business on how to submit your artwork. So unless you are in high school and under the age of 18, I really would discourage showing your work from your smartphone device or in a portfolio without an appointment, or asking if this is a good time for a spontaneous opinion of your or your friend's art when the gallery is open for business. There is such a tug for a gallery manager's time, who is often wishing to be able to carefully review the new art and taking care of customers who are in the gallery to buy the art. It is astounding how often an earnest artist who wants the opportunity to meet the curator and show their art right now, cornering me in the gallery, "Here are images of my art," they often say. To be fair, although that is a generous thought, if I *could* take the time for everyone who asks that type of query, the presence necessary to look and discuss work can take considerable time. When I am naively expected to stop what I am doing at the gallery, usually helping customers, to take a look at small images of their art on a smartphone or tablet or even ask me to go to their car right then to show me their work, it becomes unfair to their efforts and something I typically cannot do with ease and therefore miss the opportunity to possibly help a new artist.

To be clear, I do enjoy meeting artists. When artists can meet me with an appointment, serendipity timing is on our side. I think our visitors are so pleasantly surprised to see the array of artwork displayed for sale, it sincerely prompts inquiries as to the process of how an artist gets their artwork shown and sold in the gallery. I think being anxious or haphazard

introducing your art to a gallery owner is unnecessary today. We are able to communicate easily and deliberately through email, phone, Facebook, and texting. Once in a while an artist can time it right at the gallery and show up when it is quiet. However, showing up specifically to show your work before a preliminary appointment, can potentially be disruptive and counterproductive for the desired outcome of becoming a new artist for the gallery.

Before You Approach a Gallery with Your Submission

"Creativity is allowing yourself to make mistakes. Art is knowing which ones to keep."

SCOTT ADAMS,
AMERICAN CARTOONIST

So, let's assume you now have the submission protocol for the gallery you have in mind to show your art. Even if you have been in other galleries or group shows, the details below will make it easy to get organized and will help get you through the gallery gauntlet to your desired result: showing your art in a gallery!

- **Good photographs of your art:** You will want to have as near perfect photographs of your artwork as you are able to muster. Please don't rely on using your smartphone to take the best photos of your art unless you have mastered the process. The resolution needs to be pixilation free. Consider

either hiring someone to photograph your art expertly or be skillful to do this yourself. Today it is quite easy to hire someone in your vicinity who is a freelance photographer. Prices for custom shoots have come down substantially over the years and it makes sense to let someone else's area of expertise make it happen as easy as possible for you, the artist. Though understandably, you need to transport the art to be photographed and that can sometimes be inconvenient. You can also arrange for the photographer to come to your studio and shoot your artwork, and perhaps take some photos of you working in your art studio. When you have created a body of work, that is the best time to take it to the photographer for a capturing a series that tells a story. It is worth the effort. The images can be used over and over for many future projects, for your website, through social media (Instagram/Facebook/Pinterest/Twitter/Etsy/Artsy/Snapchat) and so on. You can also upload your art to hundreds of graphic design sites for royalties. So get good photographs from the start of your art career and then keep up with cataloging them, depending on how fast you create your finished work.

- **A brief letter of introduction:** Stay brief in your letter of introduction, using no more than one page of a readable point font (12-14). Introduce

yourself as an artist to the prospective gallery curator. Include where you currently reside, what art mediums you use to make art, why you make art, and what inspires you to be shown in that particular venue. Mention when you are available to meet and if you live nearby if you are amenable to a studio visit. If you live out of the area, it is important to mention that, if you will be visiting the area in the nearby future and why you would want to show your art in that gallery.

- **Website**: If you send a gallery owner or curator an email to view your work through a link to your website, make sure you have already updated it ahead of time. Websites are a perfect introduction to your artwork and history and always preferable for galleries to view when considering a new artist. If all of the work on your site is already sold, it shows you are succeeding at sales. It can also say you have no current artwork and thus you may not be ready to show in a gallery. Since websites are quite easy to publish these days, creating an art website portfolio for applying to local, regional and national galleries and art shows is something for you to consider. The website should have the dimensions of all of your art, the materials used in making the art, the year the art was created and if the art is currently for sale the prices reflect suggested retail gallery prices. If you decide to publish your

website without artwork prices posted online, then include a price sheet as an attachment when you send your introduction email and the link to your website.

- **CV or Resume**: A curriculum vitae or current resume can be very impressive. It can mean more to some galleries than to others. For the emerging artist, very rarely will the resume be extensive enough to add mystique, but be sure to add any awards received in your process of becoming an art professional. Collectors like to have a copy of your resume when they purchase your art. You can also include sales that may have occurred as important acquisitions to private or public art collections. Your resume becomes more valuable over time as you chart your participation and success in your personal art history timeline.

- **Artist Statement:** I recommend that an artist statement be reviewed and changed every year or two as your work evolves and your personal vision and impetus for making art changes. This may be when you have refocused on a new body of artwork, or changes in your artistic vision or art medium. It could be precipitated by a change in your family, your health, the place you live, the seasons, the economy, and so on. I have found that the artist statement is highly regarded by the collector we sell to. As a gallery representative, I have oftentimes

taken the responsibility to update artist statements to keep them current when I know big life changes have occurred for those artists. However, as an artist, it's a good practice to mindful of your unique perspectives and periodically review any needed revisions to your artist statement.

- **Current Photo:** It's great to have a current photo especially if you are working in your studio. Many artists have been making art for such a long time that their initial youthful photos are also a delight to see. If a gallery likes to have the individual artist photograph on their gallery website, then you may need to have a photo fairly representational of who you are now as an artist.

- **Special care and handling for your artwork:** This is rarely tended to but I find it extremely important. That is, what does your work require in handling, hanging, packaging, and shipping. If there is anything out of the ordinary, include that as well. Your work may need a forklift or a dolly, or it may need a special hanging system because of your materials. Whatever is unique to your art, this needs to be included, and I would encourage you to offer the basics in your submission because it gives the curator more information in deciding to accept your work knowing there may be special handling involved if they plan to show your art.

- **Inventory codes and a list of available artwork:** Create coding that works for you. Creating inventory codes and a list of available works can be included but it isn't as necessary until you are accepted into the gallery, and then it will be helpful if you have a coding system already figured out. You can spend time thinking about an inventory code system or create a basic number code, but whatever it is, make it clear and consistent because it will grow as you grow as an artist. Also, include the year the artwork was created.

You can well imagine the variances between gallery artists. In a large gallery with storefront hours, we have showcased over 100 artists at one time. If you do not have a coding system worked out, the gallery will. However, you as an artist can begin to take your work more seriously and track it better when you create a method that will work for you and then be sustainable over the years as a working artist showing and selling your art.

For example, one of our most successful photographers has over 300 images in his portfolio. He sells them in 4 main sizes: 8x10, 16x20, 20x24 and 30x40. He holds the latter 3 sizes in a combined limited edition of 200. The 8x10s are open unlimited edition. He has a great way of inventory coding. He uses the last two digits of the year he shot the image, and then the sequential number of image from that year, along with the size coded alphabetically, i.e. A, B, C or D. So, the 48th image he created in 1988 and printed as an 8x10 would be coded 88-48A. In addition, he also titles all of his photographs.

I wholeheartedly encourage you to title all of your art pieces and enjoy the process of doing so. It can be a challenge to not use "Untitled" for your finished art, but I suggest you try to avoid using that catch all label, "Untitled", except perhaps, if you create an "Untitled" context within a solo art show. Untitled "titles" generally create too many questions for the viewer and can border on laziness in the final presentation by the artist, especially a new artist. A title is a glimpse into your unique sensibility and allows your gallery and collector to appreciate your thoughts and intentions.

One artist I know, just collected titles, like fortunes inside cookies at the Chinese Restaurant. When it came to titling his sculptures, he would literally, pull out a "fortune" and that would be the title. So he had an ongoing list of poetic nouns and verbs that he felt aligned with and turned the titles of his artwork into a bit of a game. It worked though, and his titles appear mystical and indeed are, but with a bit of playfulness as well.

There are times when customers become bonafide collectors of your art. Sometimes they decide to upgrade from an unlimited edition to a limited edition or an original art piece. If you have a collector that may have purchased an open edition piece and wishes to up level and get the same item but larger, having an inventory system with clear titles would certainly make it much easier for that to happen.

Another artist who sold successfully in the gallery for ten years was a fine art landscape studio painter. He did exceptional local landscapes in oil on hand stretched canvas. He retired as an

art professor from the local college and then began mentoring private students in landscape oil painting of our wild and scenic area. He created a simple numeric code for all of his paintings in addition to full titles of the location he was inspired to paint. This visual journal began at the start of his serious art career and spanned well over twenty years. At the time of his passing the summer of 2017, he had painted over 500 paintings. Each painting is telling a story within a sequential history from his simplified system of recording title and number. It also shows a development arc of a pure artistic style. He photographed, titled and numbered every piece of artwork and now his widow will be able to print cataloged giclée's from the documented years he painted. He had received many art commissions over those years; from collectors inspired by the way he captured nature. His style was substantial; his artistic strength came from his ability to bridge contemporary tonality with local color and give the viewer a visual sense of place from within his paintings.

A sequential numbering system offers a simple way to see how your work progresses over years of your art production. A gallery likes the added clarity as it causes less confusion during sales. You will appreciate it over the long term and the gallery will appreciate it from day one.

It can no doubt feel overwhelming to get gallery ready. You may have anxious thoughts like, "How could I ever get into this gallery?" to "I was rejected by a gallery and it's useless to keep applying." Whatever thoughts you may be feeling, I encourage you to take the time to understand how important it can be to really be prepared and not enter the art market too early. Make

your first impressions count, and take the time you need to get everything in order. You will hopefully avoid a disorganized premature start for your desired gallery representation as you make yourself gallery ready.

CHAPTER 4
Your Authentic Artist Voice

"Our deepest fear is not that we are inadequate.
Our deepest fear is that we are powerful beyond measure.
It is our Light, not our Darkness, that most frightens us."

Marianne Williamson
American Thought Leader

Many artists have difficulty calling themselves artists even if that is their deepest longing. The well-circulated quote above by Marianne Williamson speaks to our deepest fear of being powerful beyond measure rather than any fear of being inadequate. Our ability to put down our creativity and disassociate from a desire to be an artist prevents many from taking steps forward to make their authentic voices heard.

Our expressions of art can easily be hindered by a comment, well intended or not, by someone who may not

realize the energy and emotion it took from within you and went into making your art. It is for that reason I feel the soul of the emerging artist is not so much tender as it is young. It hasn't experienced enough rejection or admiration so that it can create with self-confidence. What truths are you ready to be unveil? You can trust the process of your thoughts and the subtleties within your emotions.

A body of work has context. It carries a thread of soulful exploration where you as the artist are bringing meaning into it from and through your individual experience. It comes from an unbridled passion, beyond workshops and the obvious influence of teachers. It comes from answering the more difficult questions as to what is moving you to create and why is it important? Is there an articulation you sense, you can palpate, you must reveal? It can be the difference between expressive arts, décor, and skillful labor with art that is alive and vibrating with energy.

Have you ever stood in front of an original Vincent Van Gogh painting? Even in the midst of a busy world-class museum, I have seen his paintings vibrating. They vibrate with color, that is evident, but there is a feeling sense of vibration also. I have felt it. His expression of passion for the landscapes and people he loved still embodies his art over one hundred years old. The color, the energy can still is felt. How can a painting be the embodiment of an energetic frequency lasting for decades? How can artwork move some of us to tears? It is well worth contemplating the differences between a pretty painting and a piece of art.

One of the artists in the gallery is a skilled and accomplished watercolorist, truly among the best. He is a humble man and focused in his artwork. One watercolor painting can take him nearly a year to complete. He will spend another several weeks' hand carving an elaborate solid wood frame to elegantly compliment the image. Our patrons revere his work and it thankfully sells quite well. He prices his art affordably considering the detail and time it takes for him to produce. Rarely do customers hesitate to make their purchase of his framed and unframed giclee prints or rare original paintings. He believes moving his art out into the world is the goal. He would rather have it selling than sitting in his studio. Our art infused conversations have gone on for more than ten years. His art education began at the San Francisco Art Institute where he studied sculpture from the best artists/teachers at the San Francisco Art Institute. Several years ago he shared his thoughts stating most art belongs in the landfill. When I first heard him say that to me, I felt embarrassed, as I am also a painter and ultimately, I guess I agreed in a sheepish art forsaken way. But owning a gallery, took it to a new level of risk. This was several years ago. His words made me totally rethink my philosophy of art objectification and the perception of aesthetic integrity. In other words, what really makes art? What constitutes good art and what is just plain bad, or, as the watercolorist would say, "landfill"? These are the beginning of the harder questions you must seriously ask yourself before putting your artwork out to sell in the public eye. Though nothing should truly prohibit you from doing that, you do need to set yourself up for success if you want to be gallery ready at a significant artistic level.

As mentioned earlier, it is the fear of our Light that creates a hidden apprehension for showing our art in the world. It is an ever-present tension, the crossing point between pure originality and spirited expression that can determine great art. If we provoke our personal experience into our imagery our work as artists, can take on a life of its own. Our art will be identified through an authentic visual voice; an unveiling of our particular style will be revealed, however loosely associated with any mentor, influence, or location. Essentially your artwork must be its own, apart from explanation. Infuse your art from the source of an ever deepening creative well where your commitment to creating art will be worth your time and the patron's investment.

When we allow our lucid faculties to take over in our art making, our actions intuitively become guided in color, surface, and form. It will often reveal us to ourselves if we open and allow the whispers, staying vulnerable to the simple or complex revelations from our lives and always following our bliss in the action of making our art.

Our art making can show us our way as a light upon our personal path. If we bring integrity to our process, our voice has relevance. Our intentional actions can sometimes blow our own minds and can open us to something brand new, not yet experienced before. The real magic comes when we bring our art to the public and our art begins to translate the same feelings for others. I challenge serious artists to be open to a reciprocated relevance; when what you felt and expressed in making your art is felt by another person who is drawn to your art for reasons

of their own. I have often witnessed the serendipity of someone discovering a piece of art in the gallery that moves him or her to tears in a deeper internal dialogue. Another curious thing I have noted during the years of gallery operations between buyer and artist is oftentimes a customer who is drawn to a particular artwork appears similar to the artist who created the piece. I will sometimes mention that connection, "You would really like this artist and in fact, could even become a good friend, as you are similar in your personal resonance." The rippling effect of art making is fascinating.

Art can be medicine as John would often say in the gallery and it was imbued in the art he created. Many magic moments happen in a myriad of ways inside the gallery. The gallery truly becomes a sanctuary when connections and encounters take place. A spontaneous calm spiritual healing can even happen in the stillness of beauty. Maybe it's a deeper belief in the purpose of living that artists can touch and offer others. A gratitude for being alive, creating objects that allow the softer places of our hearts to be touched by the expression of magnificence. Thankfully, the world has artists like you who are willing to make sacrifices and take emotional risks into the unknown and resurface with originality of form. Saying something important may not always be understood by the generation it is birthed into, but you as the artist are responsible for meeting yourself and what is important to you at the intersection of your own heart, soul, mind and body.

Choose Your Inspiration
& Set Your Intention

"What moves men of genius, or rather what inspires their work, is not new ideas, but their obsession with the idea that what has already been said is still not enough."

EUGENE DELACROIX,
FRENCH ROMANTIC PAINTER

"In art, the hand can never execute anything higher than the heart can imagine."

RALPH WALDO EMERSON,
AMERICAN POET

There are many ways for you to find your inspirations and set your intentions for a new body of artwork. You are a vessel for art that only you can access, draw from and create with. This worthwhile venture will be what determines whether you make original art or fall into the repetition of copycat art. It doesn't always need to take a lot of time to be original, but it demands your undivided attention to achieve.

Everyone who has a smartphone can photograph the landscape today. However, only a select few can reveal the depths of the environment with soul and bring visibility to the unnoticed. Those who can bring the world something special to marvel and to discover are rare. They share singular keys that unlock the joys of spirit. This is why we need art, we need artists,

we need the visionary travelers who venture far and bring us back the new, the mysterious, the forgotten, the future coming, the difficult passages, the poetry of presence only found through the voice of those who encapsulate the moments with their particular vision, attention, skill and intention.

That is what you are being called to do if you are an artist. It is a calling! When you have fully articulated your visionary voice and structure of your art, you can take it to market and let your art serve others and serve you. There is no need to feel funny about selling art if you indeed create something to say that is from your heart.

There is a lovely woman landscape photographer who showed in the gallery during one of the annual Wild and Scenic Film Festivals. She lives and breathes the Grand Canyon in Arizona. The photographs sensitively reveal many facets of the magical grandeur of the canyons like visual prayers. I am not sure a day goes by when she hasn't captured at least one epic image. It is an obvious calling and creative responsibility to bring the deeper witnessed beauty of the area she experiences to all of us. Her love, intention and dedication to her art form are exceptional; a destiny matched with her enthusiasm to engage and share what she experiences in nature and this in turn has made her a wonderful artist.

When an artist creates a piece of art that matters, it combines the imagination and skill necessary to meet with the collective consciousness. This is where I believe a divine apex ensues forming a bridge of providence between spirit and matter.

Art Mining The Gold Within

"The position of the artist is humble. He is essentially a channel."

PIET MONDRIAN,
DUTCH PAINTER & THEORETICIAN

If you are committed to being an artist, know there is a body of art inside of you just begging to come into form. Your mission is to play, tease, meditate, walk, journal, vision board, photograph, sketch, and pray for the guidance necessary to create anew. When you ask the questions from your soul, trust the creative inspirations you require to be revealed to you. You were meant to create to your heart's content. When you tap into the spiritual place residing within you, an artesian well of creativity will naturally spring forth. Unique thoughts from your authentic voice will begin to come forth in ways that may astonish and surprise you, and well they should, for I believe you are a beautiful vessel meant to bring forth a channel of beauty.

The breath of creative awareness is waiting to make its song inside of you. It may feel messy and amateur at first, but anything worthwhile takes commitment to practice and steadfastness to complete. Art making is an evolutionary act. There are many stages and steps. By taking the first step in your studio each day, you will always know the next step that follows, and if you don't, just start something new! Ultimately, you are the key for making art that matters. It is an intimate way of expressing self-love. The voice of art expression has enlightened the world for centuries, so use your creative individuality to change the

world. It takes courage to express your viewpoints. Undertaking these challenges may unleash some very personal shadow-work to explore. Nonetheless, isn't that the greatest part of the inner adventure you are called to do as an artist. Art making is art mining the veins of gold within. Shadow work can reveal veins of gold, hidden unconscious metaphors ready to decode personal and collective beliefs and ultimately the sacred journey of personal awareness.

Emerging as a New Artist

"In order to succeed, we must first believe we can"

NIKOS KAZANTZAKIS,
GREEK WRITER

What does it take to get you into the studio as often as possible? When you think about your art, do you know what increases your curiosity? What activates your fascination to personal discovery? Can you imagine collectors finding your art interesting in a fine art venue? Are you hesitant to the idea of selling your art, but still wish for the artwork to be seen?

When emerging as an artist, demand for your art may be virtually low or non-existent. This can also translate as having art that is more affordable than established career artists. If your art can stand on its own, then you are probably ready to emerge as an artist in a for profit gallery. This can be seen in different perspectives. One is that your artwork hasn't been good enough to be in a gallery and that will take development. The other is

that you are a good artist but getting to a professional level is the next step into an art market.

If you know the reasons you make art and you feel you are making it from your passion, then your work will resonate on multi-levels, that is, subconscious, emotional, composition, balance, energy, etc. The ultimate gift back to spirit for acknowledging you were the vessel of creation is taking responsibility to say something meaningful visually in a unique way that simply cannot be said in words.

I am differentiating soul infused art from décor now, because making decorative art is an entirely different category and very rarely rests on meaning but can have an emotional component in strokes, fused with a bit of graphics and design. When you look at décor/art, you may not feel anything but you may think, "Oh, that's a pretty piece of art. It may look nice in the bedroom over my bed, or over my sofa, or in the hallway". The other art perspective is, "Oh My! That painting has really touched me deeply. I am feeling very connected to it!" When you stand before a piece of art you want to feel the energy. You want to feel the emotion. When a collector feels something, you can be sure she will find a place for your art, even if it means taking something off the wall to do so. In other words, she *must* have your art! That's the kind of art that belongs in a fine art gallery venue. The kind of art that moves emotion within a human being is not entirely process. To create art requires inspired action, skill, and esthetic balance. Sometimes it can come to an artist within hours, or it can take many years.

When a customer asks me how long a painter took to paint a particular painting, they generally are fishing for a standard contractor price structure for a piece of art. That is, the artist's time plus their art materials to make a piece of art should cost this much. This, in fact, is the way some artists do measure the price and value of their art. Many decorative artists work this way.

Over the years, we have had more than one artist in the gallery who borders on decorative art and coincidentally, also adjusts pricing based on a per square inch cost for every painting, no matter what dimension. I am not debating this approach; each artist must find their methodical ways that work for them. If a painting style becomes too formulaic, the method of pricing may be as well. Paintings revolving around the same color schemes and forms may be fueled by passion. However, because they are so similarly fashioned in a style and feeling they border on what I believe is décor. The art may lack dynamic energy and become tiring after awhile when it is made this way. Decorators will often be more interested in formula based artwork because it will embody trends in color, image and style. Inside a fine art gallery this type of formulaic art doesn't always sell very well and is eventually returned to the artist.

This brings up the whispered dialogue that happens in a gallery if art gives an impression of commodification or manufacturing in any aspect of an artist's work. If your art style works with your collector base, you must be mindful to bridge freshness to every piece as well as giving your collectors what they want, because that is what is selling for you. Your business sense and artistic style will build your art career and it behooves

you to strive for meaning that is reflective in your art, because it will be seen and felt by those who view and purchase.

Once you have created a successful style of art in your studio that begins to sell well, it takes a great deal of tenacity to stay aligned with your spirit if you want to stay true to your inner work. I believe this is the ultimate artist paradox, because if you are selling a style, change is resisted, but if you are really diving deep with your work, change is inevitable.

There are a large group of art consumers who generally prefer an artist to stay within the boundaries of what they are used to seeing, appreciating and collecting. If you become known for painting wild horses for five years and then start doing placid landscapes, unless your landscapes knock it out of the park, your collectors may stop purchasing for several reasons. One, your landscapes may not hold the energy your prior paintings did. The subject matter is too different for them. You may want to stick to your horses until your landscapes take on the same energy as your original successful paintings. Again, this is tricky territory. Watch that your art doesn't become pedantic and boring. Take a break in your usual routine of painting, and find something deeper within your "success paintings" or perfect your new art ideas by taking a break. Of course if you are a great artist, any medium expands your concept of beauty and can become a piece of art. That is rare... but it is also possible.

I have found that if an artist can bridge many different mediums, unless their vision and execution are well seasoned, the variety of mediums can confuse the customer. This would be

trying to show your jewelry, painting, and ceramics in the same gallery. In the beginning of an artistic pursuit, it makes sense to try many artistic mediums. However, you can be better off focusing on one medium to begin as a professional artist. Increase your repertoire, only as you need to, to expand your artistic voice, work within the limits of your physiology, or realize you just need to change to a new distinctly different expression. This also means try to stick to no more than one subject matter at a time, especially if you are a painter. If you are a photographer, then the relational qualities of photographs are important.

At the very least, don't show a variety of your artwork together because it can feel disjointed to the viewer trying to figure out who you are as an artist. The exception is when you have all of the attention at a solo gallery exhibition. Rarely will a multi-artist featured gallery actually allow an artist to show different types of artwork without a context to a collection, or "body of work". This is either because of artist continuity or due to gallery space limitations. Too many choices and variety within one artist's collection often confuses the customer and can easily diminish a sale or dwindle the customer's faith in the artist. The art must be aligned with your clear artistic voice and by focusing, your art will feel more authentic and disciplined. Too many voices from the artist can mean there is not enough focus. The collection can look like it's from more than one person or even an amateur art school exhibit. "I can do this type of art; I can work with that type of medium!" It becomes confusing and is worth winnowing out for you and for the collector as best you can at each point in your career.

Knowing your art influences is the underpinning of your art lineage. That is, what art is inspiring to you and with whom have studied. It can lead others to important aspects about you as an artist in understanding your work. This can be added to your artist biography or statement. If your work is truly a near copy of your teacher's style, it will hinder being shown in a gallery that either knows that mentor or can tell the work is lacking clarity of your own voice. Your voice is buried within the ways you learned art practices. There is nothing inherently wrong with having your lineage be seen, but I feel it needs to be a whisper or a tip of the hat to your master teachers or influencers. I can often trace the instructor many local artists have learned because the methods and subject matter are still too close to the teacher. This will position you as a student and clearly doesn't belong in a fine art gallery, unless it is a group show celebrating the teacher and specifically for that kind of student representation. This repetitive artwork can often be seen in art collectives and co-op galleries. When you strive to make your art look like your instructor's work and take it out of the classroom, it shows ability but not originality.

Your Art in the World

"Creativity takes courage."

HENRI MATISSE,
FRENCH ARTIST

Are you making art to show? Are you making art to sell? Or do you wish to accomplish both, or at least try to? If you wish to just show your work with little or no interest in selling your art, it could be due to being attached to making something beautiful and meaningful. If it's older art and you aren't making artwork any longer, or you cannot make enough work to replace when your art sells, just make a note of it. Know how making art works for you. Be honest with your process and your timing. There are many opportunities to hang art that do not require selling, but I believe you must still be "gallery ready", and sometimes even more so. You can find places to show your work in corporate office buildings, real estate offices, banks, restaurants, hospitals, coffee houses, etc. Most service businesses enjoy promoting artists for the exchange of fresh décor in their establishments. This will get your name recognized as an artist within a reasonable radius to your art studio, just by showing your art even if the work isn't for sale. You may even get a special order commission from someone who likes your work! When you know whether you wish to show and not sell your artwork, then you won't waste time with a profit oriented business gallery when submitting your art to galleries.

Regional for-profit art galleries are part of a fragile and fluctuating discretionary economy. When you make a commitment to a gallery they will take you seriously and are making a commitment to learning about you, training staff about you, uploading your images to their website, painting walls, printing materials to give customers, putting your name on advertising, and staying open for business to the public with committed store hours. Be mindful and realistic when getting gallery ready. Set your intention, know your voice and decide how you would like to be seen as an artist. Then no matter where you decide to go to show your art, you will be successful.

Finding Clarity as an Artist

"I am seeking, I am striving, I am in it with all my heart."

VINCENT VAN GOGH,
DUTCH ARTIST

What is your big "why" for making art? Do you have a mission or focus? Are you trying to say something important to a specific audience? Are you moved by a cause and inspired to paint or sculpt from that passion? Do you create your art because it fills you with a sense of satisfaction? Do you experience doubt or clarity of purpose?

It is important to actually know what is moving you to create art if you are indeed serious about showing in a gallery. So take the time necessary to think about it if you haven't already done so. You may be attached to the way you want your art ideas

to manifest. This can be a serious hindrance or an incredible help, depending on your tenacity. It all depends on how you intuitively unpack your logic and reasoning. Don't be afraid to give yourself a lot of psychic space to wait for answers.

Have you ever made bad art deliberately? Leigh Hyams was the first mentor I knew that would give her students permission to go "make bad art" on the first day of her workshops. It can feel very freeing to just go into your studio with the sheer purpose of allowing yourself to actually make bad art. It sounds silly, but you never know what may emerge from that state of joyful detachment. Especially once your art starts to sell and you begin to feel pressure to make art that sells. Picasso always said after he mastered the art of painting, he would spend the rest of his life finding the childlike experience to paint with pure abandon.

So, periodically ask yourself the question, "Can I be okay if I make "bad art" today?" Be willing to play in your studio without judgment but simply for the sake of allowing creativity to organically flow from you. When you experience unbridled play, your passions rekindle without a need for your art to be anything in particular. This will often clear your mind for deeper creative visioning.

The Idea of Precious Art

"Tell me what is it you plan to do with your
one wild and precious life"

MARY OLIVER,
AMERICAN POET

Have you ever noticed a sense of attachment to any of your works of art? That it is hard to give away for any reason, either because a particular art piece was executed to perfection or maybe all of your art in general feels that way?

It is a good thing to note and understand the levels of attachment you may have to your art. Each medium will have a significantly different relationship to attachment. An original painting will have a different attachment then a photograph that can be duplicated. If you are attached to your art, how attached are you? Attachment is good, but if it is too much then you will not be able to sell your art with ease. Seeing your art as too precious is bittersweet. Ultimately, as an artist, you are the one that is the most precious, simply from a transcendental point of view, because you are human with the capacity to create beauty. Too much emphasis on the object as precious is a very fine line. The term precious and value are not necessarily synonymous. Precious is great personal value or pleasure. Value itself generally means monetary. Art that you have created can mean both.

As children, most parents thought everything we made was precious. They often displayed or saved every bit of our creativity, from crayon drawings on manila construction paper

to scribbled finger painting. In high school, many a youth are so tuned into the creative forces, they often produce some of the best work of their lives. Expectations of artistic ability can rise and fall within a few years of graduation, after we get into the conforming river of life. Disenchantment often ensues and before long, being "good at art" becomes a distant memory that has taken harbor inside the heart. When we are adult artists, our memories of the preciousness of our work can still linger in our consciousness as we experience fear letting our art go out into the world.

I have witnessed submitting artists bring in their solo "masterpiece" from their past. It may indeed be an excellent piece of artwork, perhaps done 10 to 20 years prior. Unfortunately, not being current art, without current context or within a retrospective, prohibits a gallery to just sell your one masterpiece. Harshly, it rarely implies you are a good artist today. Those of us who cleave to our youthful artistic talents must realize you can still "be" an artist, but your one or two or three renderings from school or a great art class will not deem you gallery ready.

You must put the time into your art, with your purpose and your methodology to join the many artists who came before you through the centuries. As an artist, it takes a tremendous amount of time and dedication to create a body of work that is interesting, means something to you and can captivate the viewer. The real trick I see is finding that summit where the artwork speaks, whether you are nearby or not. You have satisfied all that was required from the muses and in return, you did indeed create a masterful piece or pieces of art. Bravo! This means you have

taken the time and created a place for making your art! You are far along in your preparations to be gallery ready!

How Do You Want Your Art to Make People Feel?

"To send light into the darkness of men's hearts-such is the duty of the artist."

ROBERT SCHUMANN,
GERMAN COMPOSER

Think about how you would like your art patrons to feel when they view your work. What kind of energy would you like your art to resonate with when it finds its forever home? What type of imagery do you want to invoke and have your name associated with? What motivates you to make your art? Is it a way of keeping busy and active or are you really engaged and taking deliberate action to say something? Where does your work resolve itself? What times in your art making do you find yourself in the zone? Are you happy with the overarching theme of your creative path? How physical are you with making art? What thoughts are you having when you are creating your art? Do you set any intentions before you begin?

When it comes to décor, you are actually matching colors or making plans for a painting that is meant to be in a certain location, or you are working thematically. This is different than actually creating work from a place of inquiry or questioning

of ideas. Can you feel what the difference is? Now a body of conceptual work can certainly embody both, but make sure you recognize the difference, as it matters in the art world.

You might begin to wonder if you are ever going to be good enough to be gallery ready. All artists can get to where they want, eventually. Individuation is essential though, to create something uniquely your own. It's a perfect intersection of originality and viewer response to an artist's work, a symbiosis in non-verbal understanding. It is important to not compare yourself to other artists, but to appreciate and study the ones that you love and who inspire you.

There is so much to learn from going to museums and art galleries and looking at the details of masterful execution. Know this is how you learn. Seeing the stroke of a genius painter, or even the lack of any brush strokes at all on a masterpiece can send me into a deep and profound merging with that artist. I imagine him creating the painting and all that it took for him to start and to finish. I believe one of the reasons old masters artwork still resonates so strongly today is because of the energy it took in time and attention to create artwork a hundred or more years ago. The artists of our history were not able to simply go online and order from an art supply store and have their choice of supplies delivered right to their doorstep with free shipping. Nor did they have the immense selection of colors available to them. They had many limitations and had to have knowledge and skill to create paint before painting, or quarry marble before carving.

Even if you haven't gone to art school, it is still entirely possible to be gallery ready and an art success because the resources for learning today are immeasurable. One can learn from specialized art coaches, video trainings, adult school, colleges, mentorships, workshops and more. Nothing needs to hold you back from pursuing an art career. Certainly not going to art school can be a dark cloud that hangs over many who dreamed of doing that sometime in their life. That certainly was my story. This desire should not prohibit your wish to be an artist. You are able enough to make unique art and if it isn't ready yet, it will be if you work at it. Oh, did I say work? Yes, the most interesting work on the planet, taking raw materials and making them into art that holds value is a source of great creative satisfaction.

You must learn how to trust your inner guidance, your inner voice, the bits and pieces, or clues, that give you insight and information that pertains to you in your creative inquiry. The world works so mysteriously in the creative realms. I have found making art to be a strange contemporary shamanism; a way of manifesting a reality into form through intentional exploration fueled from the psyche. It is fascinating. Through those cycles of creation, discouragement can sometimes drop in and begin to rain while you're still trying to make rainbows, or something else. Be vigilant; know that discouragement in any area of your life is a robber of life force. It certainly doesn't belong in your studio, in your art or in your mind. So take a stand to rise above the discouragement and create like Picasso did, with fervor!

Is Your Art Ready to EMERGE?

Get organized with your voice, your clarity and the purpose of your art and you will be flying high with a body of work far beyond common home décor. Ask yourself the following questions to see if you are ready to **E-M-E-R-G-E**! Make sure your art is gallery ready or at least ready for the next step in an art career and if the answer is yes, then now is the time for you to emerge as an artist.

E-Energy
Can I feel the energy of my art?

M-Momentum
Is there a dynamic momentum in this body of artwork?

E-Engagement
Is there a sense of personal or social engagement in my art?

R-Real
Does my art express what is real for me?

G-Generative
Are my ideas generative?

I-Interesting
Is my art interesting?

N-Narrative
Can I clearly discuss any narrative behind my art?

G-Genuine
Is my art a genuine reflection of my spirit?

CHAPTER 5
Find Your Art Market

"There's no retirement for an artist, it's your way of living so there's no end to it."

HENRY MOORE
ENGLISH ARTIST

I t may sound odd to hear, "find your art market," but it is worth asking in terms of where your passion will find its play, that is, where will your art likely sell. After all, being gallery ready is about marketing your art in the right place. As beautiful as your artwork may appear, it must have the right environment for a particular genre, clientele, region, and so on. If you love to paint seascapes and live in the forest, we can bet there will be little to no interest in customer/collector purchases from your region. Seascapes or any ocean imagery will always sell best along coastlines.

Regional galleries tend to sell landscapes of the area from local artists in that region. Contemporary abstract art may

have difficulty finding a purchasing demographic in more rural communities where many elegant homes have picture windows. Finely crafted windows welcoming nature's changes may be the first choice for beauty in the home, often replacing the need for "art". If a community doesn't show conspicuous wealth you may rarely find buyers for higher priced fine art. In metropolitan areas where there may be more museums and galleries and even outdoor fine art show venues, art sales can be a booming business. Abstract paintings and dynamic sculptures are often purchased for corporate campuses and large office buildings. Art buying is directly connected to those who have the ability to not only appreciate art, but also to purchase art with a lifestyle to understand the value and be able to care for the art once it is taken home.

A successful local oil painter of large format abstracts sells her art nationwide. Her work is heavy with texture, vibrant color and lots of energy. Her paintings are stunning in contemporary homes, corporate offices and homes that are an eclectic mix of art and antiques. Our regional customer base seems limited for her style of art. Many who come into the gallery are confused with the lack of image in her work. However, visitors from the Bay Area and Reno/Tahoe seem to appreciate her artwork more. A few of her older pieces have sold in the gallery to the local clientele. I have wondered if it supports the thought that town and country living is a bit "behind the times" compared to the fresh creative buzz in urban areas.

Portrait genre can take time to sell because of its more personal nature. Figurative work seems to go in cycles and appears to be gaining another level of appreciation with collectors. Commissioned portraits of people and pets can be very lucrative for an artist. Figurative art in a gallery must have some type of an edge and be imbued with emotion to make the art compelling enough for a collector to purchase. One artist who grew up here and currently resides in New York, is in the top one hundred portrait painters in the country. She deftly pushes the envelope of surprise with her portraits seamlessly painted in tense dynamic counterpoint imagery that keeps the viewer engaged. Her mild manner adds to her mystique as an important artist to watch. Ironically her artwork sells very well in New York, yet it did not in her hometown.

It takes time to develop your visual voice, the voice that is not a copycat reproduction, or home décor. You will want to find a way to create a work of art that is itself a merit of beauty, a soul expression. Making serious art, not necessarily serious context, means art that can go to market with confidence. This happens because of the time, attention and intention you add from the experience of your artistic reality. It is from this point financial compensation becomes an integral part of the art market equation.

Titles for Your Art

I touched on titles earlier, but to reiterate, the title of a show and the title of your art can evoke so much in your viewer. Your

imagination, visually and with words, will touch them in all aspects of the art you are sharing. Titles can be mysterious, arising like a poetic stanza in the midst of you creating your art. Or a title can be the intentionality that comes before the art journey begins giving a bandwidth of context and structure. Untitled works are complicated to the viewer because they lack context. It is a gift to give a title to your work. It sets the emotional tone for your entire presence and provokes the curiosity into your art inquiry.

Personal Branding

"Be yourself, because the people that mind don't matter, and the ones that matter, don't mind."

THEODOR SEUSS GEISEL,
POLITICAL CARTOONIST, ARTIST, AUTHOR, POET

In the presence of the world we now reside in, personal branding has become an important part of being an artist. In the last number of years, as younger creative entrepreneurs have emerged, they have incorporated their art into a branded style. Think about creating, discovering and being discovered. Since we are able to transfer artwork in a myriad of applications, branding your name and signature style can be useful for the artist, depending on their medium and long-term goals. Whether you are showing your work in a fine art gallery in your local town or in a fine art gallery online, or in a high end gallery in New York, I think the more you delineate your uniqueness into a style the more reflective your art signature will be. It is who you are, what

you do, why you are doing it and whom you know. The process of art making can oftentimes be a solo journey. Deliberate branding can help create an identification of who you are as an artist in our image driven world and make it easier to increase your visibility, which creates more collectors wanting your art for their homes, offices and corporate environments. Branding recognition is about successful marketing which in turn fuels your experience of passionate expression.

The Value of Your Art

"I try more and more to be myself, caring relatively little whether people approve or disapprove."

VINCENT VAN GOGH,
DUTCH PAINTER

You the artist, ultimately decide the value of your art! The gallery will no doubt give you their professional advice. Many factors exist within the scope of pricing. If you really wish to market your art, when you begin you must be competitive. Emerging artists cannot just price their work at the pricing of already established artists. Some galleries cater to those with large discretionary income. Be aware of your location when setting prices. Once established in your art along with increasing demand, the sky is literally the limit on the value patrons of the arts are willing to pay for art.

Allow the market to determine best pricing, that is, the price that sells the art. If you start too high, you will know within six

months to a year, or even the night of an opening show. When you are introducing your collection and feel you may have started with prices too low, it can still be a win for you because it has created a buzz of interest and sales in your work at the beginning. If the art is good when introduced to the buyers, and well priced, it will sell without hesitation. Rarely, if your price is too low, customers may wonder why the price seems contrary to the value. The best rule to go by is generally if someone likes your work, and the price is affordable to the buyer, there is no vacillation and the decision to buy is direct, the way the gallery enjoys making art sales!

A lovely printmaker, who drew exquisitely detailed originals, priced her work modestly. Most of her renderings were real bouquets from weddings, anniversaries and wildflower bouquets in addition to Victorian interiors. The lines were drawn in one sitting and the detail was remarkable. She even had commissions for special bouquets. An avid art collector in her own right, her skill as a print maker was 50 years strong. The prices of her framed and unframed limited edition prints were so well priced that anyone who wanted her art purchased it immediately including a growing number of young collectors. She wasn't financially dependent on the income from art sales, but every month she received check from the gallery.

Declare Yourself an Artist

"Art is the only way to run away without leaving home."

Twyla Tharp,
American Dancer, Choreographer & Author

Even if you have never actually sold or shown your art, this does not prevent you from calling yourself an artist. What it takes to do so is to be able to see your art beyond your emotional connection to it. When you develop your art through personal and creative inquiry, you begin to see deeper into your meaning and why you make any art at all. If and when you are moved within to make art, whether you show or sell your artwork, you are good enough to declare yourself an artist.

I've seen many artistically talented people cower when asked, "Are you an artist?" It's a designation that carries many weighted beliefs and feelings associated with it. It seems to have an invisible crown of high expectation. If you state, "I am an artist," what goes through your mind? It's important to know how you feel when you own that title so you are clear and purposeful in your art. Being comfortable with your artistic expression is necessary when you are placing your art in the world.

Countless years ago, it was the artists who were revered. They were the ones who could see beyond the obvious and capture what was occurring in their day and age; the important beliefs about the spiritual life and the day-to-day life. The paintings and sculptures left a profound repository of beauty and symbolism in addition to depictions of commoners. From

the still life paintings showing hand-hewn wooden tables laden with food in candlelight, to cherubic angels at the feet of Mary and Jesus, or the hand of God reaching man on the ceiling of the Vatican. The ability to form something in the mind and create it to life-like proportions were witnessed and executed as a God given talent.

Were you the artsy kid in grammar school who saw things differently from the other children? Children with natural born abilities to draw, doodle and daydream sometimes appear to be slower learners. They go off into their own world or become easily distracted with their own ideas. They do life and learning differently because they think differently. What types of ideas and beliefs did you have or hear about artists when you were growing up?

Eva Hesse, the progressive woman sculptor is known to have said, "Excellence has no sex." Her bold understanding paved her way into a male dominated art world, making a profound mark inside a brief life. My experience taught me differently, since most artists I knew were men through the art biographies I found at the library. I felt hindered as a woman wanting to be an artist. Fortunately, younger women are no longer impeded with that naïve point of view as they merge art and life with more ease. This is altogether healthier than their generational predecessors, many who separated their artistic passion into craft and hobby making or signed their art, "Anonymous". Art as a way of life is the reason you may want to be in a gallery and do what John Mowen often said to me, "Get behind your own art!"

CHAPTER 6
Gallery Representation

Know the Quality of Your Art

"It is the quality of our work that will please God, and not the quantity."

MAHATMA GANDHI
INDIAN ACTIVIST

I t is important as an artist to be as specific as you can about your choice of medium and how the art you make needs to be handled and cared for. This is a courtesy to your gallery and subsequently your customer, and ultimately a reflection on you as the artist. If you have painted a lovely watercolor using student grade paints, rather than professional highly pigmented watercolors, you may have overlooked the importance of archival materials. In the case of watercolors, light fastness is critical. If a customer places a non-archival painting or photograph in a well-lit area, she is sure to find her artwork permanently damaged

over time. It is important to include with your art the materials you used and the care of your artwork so when the gallery sells the art, this information is included in the sale.

Encaustic beeswax layers were an ancient way of preservation. It later became used as an artist medium. It adds depth and dimension to an art piece. It also creates a delicate surface. It will melt, chip and scratch easily. Paintings, sculptures and photographs can be manipulated by continuously layering uniquely different surfaces. Beeswax was the original wax used but since then, other waxes have become available with different melting temperatures. A pair of artists who showed in the gallery created colorful concrete houses painted with encaustic wax. The house surfaces were delicate on these heavy weight whimsical tabletop sculptures. Therefore they had to be handled with care, wrapped only in wax paper, before being boxed to transport out of the gallery. Any mishandling scratches an encaustic surface.

When we first opened, we had an unfortunate mishap with an encaustic painting being returned to an artist in San Francisco. The cool coastal climate of the City made it a good place to show, and sell encaustic art. Getting her work back to her became a challenge in the back of my 2005 Prius on a cloudy three-hour drive. The hatchback window increased the solar temperature and melted the delicate beeswax on top of her painting. The damage was dramatic, the artist was angry and it taught us a big lesson about encaustic painting care. The artist could have made her own boxes for transportation or could have had crystal clear handling instructions. It was a costly expense for the gallery, which could have been prevented

with the right information. When an artist can provide specific care instructions for her artwork, even to the point of making insulated boxes, that artist's artwork is truly gallery ready!

One of our best selling and appreciated gallery artists makes extraordinary ceramic figurative sculptures. Each one is hand-built, carved, kiln fired and painted, taking more than 20 hours of time. They are very fragile. Anything fragile is always double boxed when packing or shipping from the gallery. When making something this breakable, it is a courtesy to provide boxes to your gallery. It may sound like extra trouble, but just factor in the cost of your special packaging materials with your artist cost when you deliver to the gallery. With shipping costs so high, now we solely rely on outsourcing to local shipping experts for our packaging needs and pass the exact shipping costs onto the consumer.

New boxing, which shipping businesses stock and use daily, are critical for current insurance claims. It makes economic sense and ensures the safety of the artwork. Shippers should know how to ship just about anything but don't take that for granted. When it comes to your artwork, leave nothing to chance and give your gallery explicit instructions for shipping. Over the years we have had a number of breakages in the shipping process and nothing feels worse to an artist, collector or gallery then to have USPS, DHL, UPS or FedEx mishandle a one of a kind package.

Please do not assume you can be too careful when it comes to handing off your art, be it to a gallery, shipper or a customer. All art has to be packaged carefully because of its originality and fragility. Once destroyed or damaged and subsequently repaired,

it unfortunately fails to hold its value, even if you believe in Wabi Sabi, the belief that an object of beauty is "imperfect, impermanent, and incomplete".

If your art is original, treat it as you would a baby. Take the precautions to find the proper materials to pack up your art well. Add your costs to the cost of your art. It is worth every penny. It is a great help to a gallery showing your art and will insure safe passage through the channels to get to its final location. When using packing and shipping companies, find out their shipping practices and put yours in writing when handing off your work. Go the extra mile to ensure your art is always protected.

Another sculptor who was in our gallery created very fine steel wire sculptures and custom boxes for each piece. The boxes were nearly a work of art because she cut little bits of Styrofoam to keep hollowed areas from crushing and glued a photograph of the art piece on the top with the quirky title and her signature.

If your artwork requires more than a simple sleeve of protection, consider taking the measures necessary to protect your art. You will always be glad you did, so will the gallery you show in, and above all, your collector will notice the care you have taken with your art.

"Talent alone won't make you a success, neither will being in the right place at the right time, unless you are ready. The most important question is: "Are you ready?"

JOHNNY CARSON,
AMERICAN COMEDIAN

A Gallery Ready Checklist

Ceramics

- Are there rough nicks and edges on the ceramics?

- Are the ceramics functional or sculptural or both?

- Are the ceramics microwave, oven or dishwasher safe?

- How delicate or sturdy are your ceramics?

- Do you accept special orders?

- Do you provide any special boxes or care cards?

- Do you wood-fire, gas-fire or electric kiln fire your ceramics?

- What cone do you fire your ceramics?

- Do you customize your glazes?

Fiber Arts

- Have you provided fabric content on a label or card?

- Are your pieces one of a kind and one size fits all?

- What are the washing instructions or is it Dry Clean Only?

- Do you take custom orders and if so what is the turnaround time?

Jewelry

- What material do you use to make your jewelry?

- Is your jewelry Cast, Fabricated, Wire-wrapped, Designed only

- Do you use real stones or simulated stones?

- Have you created a care card?

- Have you created an inventory system?

- Are your jewelry tags simple and not detracting from the jewelry?

- Do you take special orders, do repairs or match a missing earring?

Painting, Drawing, Printing

- What type of color media do you use? Watercolor, Oil, Acrylic, Pastel, Mixed Media, Pencils, Charcoal, etc.?

- Are you using archival professional grade art supplies?

- What type of surface are you painting on?

- Is your art already framed, unframed or needing to be framed?

- Will you be making reproductions from your originals?

- Do you take commissions from clients?

- Is your artwork completely cured and ready to hang?

Photography

- What is the printing method of your images?

- Do you do your own printing or use an outside resource?

- What type of paper do you use?

- What image sizes are available?

- Is your art available framed and unframed?

- Are your photographs in limited or open editions?

Sculpture

- What are your sculptures made of? Bronze, Resin, Acrylic, Steel, Wood, Assemblage, other?

- Are your sculptures Limited Edition?

- Are they only inside installation or can they also go outside environment?

- What are the long-term care instructions?

- Do you need to do the installation of your work?

- Are there special hanging instructions and/or hardware for your art?

- What sizes of your sculptures are available?

- Do you do commission work?

A Gallery Contract

If your work is accepted into a gallery, congratulations! This is a coveted experience. It will be important to always have something in writing to protect you as the artist, as well as the gallery. This keeps the lines of communications clear with expectations and also eliminates any possible assumptions from either party. You will want to find out if you can review the artist/gallery contract ahead of time, before you begin any forwarding processes, and be clear on what is expected from you as the artist and what you expect from the gallery as your representative. If the gallery does not have a contract, be sure to have your own and be prepared to use that one just in case.

Most contracts are general boilerplate. If you can review the contract prior to coming into the gallery with your art, this may avoid any misunderstandings. It also will give you time to make any amendments if necessary. Most galleries are fine if there are personal addendums. Each artist is different and so is each gallery. Make sure you acknowledge questions for any upcoming shows and how long your art will be in the gallery. Also, find out when will be the best time for you to drop off your art and the best time for you to pickup any art that didn't sell during the contract time.

Make sure you write in the contract if there is a leeway in your pricing. Are you amenable to price adjustments and if so, is it by percentage or an amount? In other words, are you flexible in your pricing if a customer wants to "make a deal"? Do you have a specific way you like to be contacted? Is it with an email? By phone? By text? Are there days you do not want to be contacted by the gallery, or certain times of day better than others? You will also want to make sure your mailing address is clearly spelled out for the gallery to send you a check each time your artwork sells.

Gallery Contract Points to Consider:

- What is the length of time for consigning your art to the gallery?

- What is the split commission policy with your art in the gallery?

- What is the margin you will allow for customer discounting?

- Who is responsible for shipping art back to artist?

- When is the consignment payment due to the artist?

- What is the artist/gallery layaway agreement?

Dropping Off Your Artwork to the Gallery

Find out from the Gallery Owner or Manager the best time of day and day of the week to drop off your art. Making an appointment is always a polite thing to do. If you are out of town, that's okay, windows of time also work. It really depends on the gallery. Worst times of day are generally the weekend! I have had many an artist show up on a Saturday afternoon dropping off their artwork, only to have it put in storage for another week or so. It's awkward because we never have the time to discuss the art, care, paperwork, etc. It becomes rushed and doesn't lend itself to the most optimum structured and deliberate entry point and new relationship. This has actually occurred at a few gallery openings. We have had artists who were not prepared and missed the opportunity to make it into a show, because of their tardy delivery.

Once you are accepted into a gallery or a specific show, make it a priority to get the work into the gallery in a timely fashion. The worst thing for a gallery at the beginning of a show is finding

the best placement for last minute arrivals of work to come in. This delay can upset an entire show. It happens and is often preventable with pre-planning. So try to avoid being last minute in the delivery of your art to show in a gallery. If its possible for a gallery to do their important set up and hanging well ahead of the intended crowd, it sets up success for the artist who delivers early, not so much for the artist who runs behind schedule.

How Do I Set Up at the Gallery?

You may or may not be needed to set up your art in the gallery. It depends on many factors, such as: Are you having a solo show? Whether you are coming into an existing group of represented artists. Whether it is a temporary show for a popup or special exhibit and sale, such as a social cause. If your work is heavy, or unusual and needs extra attention, the gallery owner may appreciate the artist lending a hand, and this can be a great boon to the gallery. As an owner, I love when the artists come and give a hand with their work. Perhaps you would like to have a certain color on the wall to enhance your work or you require special lighting. Most galleries have a workbench with tools for the extra attention and special handling art requires. It's a good idea not to assume the gallery understands how to mount, hang, attach, or move your work. If your sculptures are unfinished on the bottom, please make sure you have added felt pads to prevent scratching on gallery surfaces or future customer floors. If you have put the edition numbers on the bottom of heavy pieces, make a note of it to the gallery staff so they are fully aware at the time of sale.

All art pieces should always have your signature. Dates on paintings can be put on the back. Dates can be suspect depending on the artist and type of work. Sometimes an artist is "channeling" work that is years ahead of its time to be understood or appreciated, take Vincent Van Gogh for instance. Don't be too discouraged if your art doesn't sell when brought into public view. It may not sell initially, but strange as it may seem, if the art comes out for a retrospective in the future, it can be snapped up because it resonates with the field of energy happening in the future and not currently.

Keeping Track of Your Art

Generally, if you want to be in a gallery, keep your work fresh. Select only your best art and replace it when your pieces sell or when you have a new body of work you are excited about. If you give more art to a gallery than a gallery has a place to display, find out where your work will be stored. It behooves you to always keep track of your artwork in a gallery, especially if you load them up with extra work. Never assume or lose track of your work at a gallery.

If you are having a show, a gallery will want to have back inventory of your work to show prospective collectors more than what is exhibited on the floor. There is an idea circulating in art sales that if you keep a special piece or two hidden from the general public and bring it out to show selective art patrons interested in fresh art it gives a feeling of distinction when they are shown something "from the back"!

Most of the art in my gallery is elegantly displayed at all times and we treat everyone respectfully as prospective buyers of art. It is vital for a gallery to be aware of an artist's capacity and their depth and breadth in skill. The reason being, if a piece of art isn't available on the gallery floor, a staff member who asks the right questions, can often create a sale for a commissioned piece of art or know of something currently in inventory. This often happens in the gallery. Staff versed with a good knowledge base of your work will be more than glad to increase the capacity for your art sales. Commissions happen this way. It is exciting to see a piece of artwork created for a client who didn't even notice the work in the gallery but let us know what they were searching for. They often end up with either a commissioned piece of art for their home or office, or something special that came in from the artist studio.

Stay Connected to the Gallery

Once you are an artist in a gallery, take the time to stay in touch with the gallery. Periodically give the gallery a ring during a weekday to check and see how your art is selling. Even sending a brief email will likely be appreciated and oftentimes pay off beneficially for you in the sweet serendipitous sales that happen when your energy flows positively towards the gallery.

Given the large bevy of artists currently at my gallery, it is near impossible to have the time to call each artist and chat monthly, though it would be fun if I could. However, it is always such a pleasure to hear from any of our artists. There is usually

some bit of information to tell them, either about their artwork, a customer, an inquiry, or a sale, more work needed, or a blip in the gallery with their piece, or, at the worst, it's time for the art to be picked up.

If the exhibiting gallery you are showing in is local, it will certainly easier, and sometimes even better, to stop by and say hello once in awhile. It needn't be weekly, unless on your regular route, but take note, we experience a marked improvement in the sales of our artists work who check in with the gallery on a regular basis. I encourage artists to come and enjoy the environment, have a cup of tea or coffee, or even a glass of wine or ice cold beer. When they come in and relax and talk more about their work, what they are currently envisioning, etc. it allows the staff and interns to hear you speak about your art process. Sometimes a spontaneous lunch can occur, and with art there is always so much to discuss. If you come on a Saturday afternoon, customers love to meet and greet the artist. I assure you, you will learn something from speaking to the public, being in the gallery and watching the ebb and flow of visitor traffic.

Perhaps it's all about the energy connection. As the energy flows from you into your art form, from the art into the gallery, from the gallery to the people, and finally home to your collector the deliberate connection with the gallery can significantly influence sales. See what happens if you simply add the intention of gratitude towards the gallery and staff. You may witness a direct correlation working for you in the gallery. Those thoughts are things, and I've experienced hundreds of instances

of reality shifting due to intentional positivity towards the art and artist within the gallery.

Consignment: A Give and Take

"The more we share, the more we have."

LEONARD NIMOY,
AMERICAN ACTOR

I am always taken aback when someone walks up to me out of the blue while I am on the gallery floor and says, "I am an artist, what does the gallery take?" It feels like they think that is what a gallery is all about. What is the gallery taking from the artist? Certainly there have been many galleries that have been run where the artist is not handled with the highest regard. However, that is generally not the case today as the small business climate is vulnerable to the new ways artists can sell their own work, primarily online and at art shows. The fragile discretionary economy that buys art fluctuates. Hundreds of galleries have closed in the last 10 years. So the question really becomes, what can the gallery do for me as an artist? Or how can I partner with the gallery because their environment really enhances my art. It allows visitors, customers and collectors to experience my art in a gallery environment. As I have mentioned before, the gallery and artist must now partner to be successful.

One hand washes the other, as my sister-in-law would often say. Though I think today an artist can certainly survive without a gallery, but a gallery clearly cannot survive without

artists. So if the gallery is reliant on the artist, the structure of both parties must benefit and be mutually supported. The artist must not have resentment towards the percentage a gallery needs to run which includes overhead costs and making a profit. If there were no galleries, collectors would not be able to easily see and experience art. Purchasing art would succumb almost entirely to the Internet, which is actually happening more and more. I think it would be great loss to cities and communities throughout the world. It could happen and in some areas, it is happening. Certainly many fine art galleries that thrived in the 90s, and early 2000s couldn't survive the last five years. That has to do not only with the economy, but also with rising costs of real estate, as well as the changing population of avid art collectors.

Many of our artists are now retired or have passed away. A new breed of artist is more tribal, reusing, upcycling, showing and selling collectively. This further emphasizes how art scenes are shifting. The jury is still out whether storefront galleries will be able to continue. There appears to be a growing idea of simplicity, living with less and a general distaste for collecting or being attached to things, and living a more fluid life. In the 80's and for the next thirty years, a large segment of society collected and stimulated the fine art and craft economy. Galleries were wonderful businesses full of American Art. Artists thrived and were able to live comfortable lifestyles earning cash at blossoming art fairs and art galleries around the country. They bought their homes, built stellar art studios, and had a real art market to make and sell their work.

It has been nothing short of an ongoing balancing act to keep a gallery viable through the twists and turns of the last twenty years. So when I am asked the question, "What percentage of the sale does a gallery take from an artist?" my lil' feathers get a bit ruffled due to the decades of weathering the rainy days of regional gallery ownership. The answer to the question is sincerely a personal negotiation between your needs as an artist and the relationship with the gallery. As I was once told by someone years ago, "Everything is negotiable". Each gallery has its own set of expenses, so there are no hard and fast rules. Generally though, a good starting point seems to be a 50% split between the artist and the gallery.

It is imperative that if you are going to sell online your prices must be the exact same prices as selling in the gallery. The reason is the collector/shopper will be looking you up and will purchase at the best price. To be fair, the thought of using the gallery as a showplace to catch customers is an unfair business practice. The overhead to keep a gallery going is immense and everything rides on sales. To compete with the gallery who shows your art, is counterproductive. We know our very best selling artists are the ones who show in the gallery exclusively. They send their clients to the gallery. Why? We pay the gallery rent, staffing, internships, fees, utilities, and more, so they can do their art without interruptions and the gallery can handle customer situations:

- Gallery storefront business

- The long dialogues that brings about a sales

- Sending art out on approval.

- Track layaways; take credit cards, pays sales taxes etc.

- Handling and shipping of the artwork.

- Delivery to customers set up or hung.

- Customer inquiries, special orders or commissions

- Advertising, gallery openings

What Makes Your Work Shine in a Gallery

A gallery of artists who make a commitment to partnering with the gallery makes a difference to the viability of a gallery. It is a financial investment to introduce and keep an artist in a gallery. The subject of money and sales are an important discussion. A gallery can be a challenging business model. Most people who enter a gallery are looking. If the gallery is not an artists' collective it is there to earn and profit for the artists, the gallery owner and the staff. It serves the community by offering a cultural experience. It requires a tremendous commitment to pledge your time and energy on the sales of beautiful objects.

If art doesn't sell in a reasonable amount of time, the energy stagnates and nothing around it seems to sell either. I have looked carefully at this phenomenon. It's part of the "dump truck" phenomenon. It happened often when art show artists left the art that didn't sell at shows at the gallery for a season or longer. Or they would take their best work out of the gallery too soon

for their upcoming shows. Or they would forget about their art at the gallery entirely. This gallery became the repository for unsold work after years of taking on so many artists.

When I took over, I moved art around the 2500 square foot gallery space, created new wall colors, new pairings and exhausted every manner I could think of to get the art sold to a buyer, including deep discounts as the last resort. For years, the gallery had too much beautiful but non-selling art on the floor. People visited it as a contemporary art museum. It was a long tedious process to clear out the art left after John's death and begin to add fresh art with new meaning to compel buyers to make swifter decisions to purchase art at the gallery. A museum is wonderful as a non-profit and run by docents, but as a business in this humble town, it doesn't pay the bills.

It's taken several years to change the game to where the art is now rotated frequently. Art isn't stored and the artist is committed to bringing or sending new work as it sells, or every 3- 6 months. The model works and our sales of fine art are increasing. So, remember, keep your art fresh in your gallery venue and know the gallery is working for you.

Your Art Business, Gallery Business, Collector Business

Merging the needs you have as an artist to get your art in a gallery, seeing the importance of a gallery getting their percentage of the sale of your art, and seeing that collectors are always serious

when they spend money on their choices of art, is a triad of general uncertainty until the point of purchase. You determine your price, and hopefully your work will, at some point, resonate with someone deeply enough for them to part with their money to buy your art.

If your art actually resonates regularly with many people, then you are more apt to sell at your asking price. That's optimum, and often rare. If it is rare, and maybe 2 or 3 people show an interest in your work over a long period of time, then the gallery will feel more inclined to suggest lowering your price. Most regular purchasers of art today seem to want a deal when they make their purchase. As annoying as it is, it is unfortunately the case with many art buyers today. That's why when you price your art; you will want to give your gallery a range to work with in the event of a requested discount. That percentage will be whatever feels right for you as the artist. If you happen to leave your work unattended for a very long time at a gallery, galleries will make markdowns like any other retail business competing to complete a sale. The mounting expenses for a retail storefront keeps a gallery motivated, so keep tabs on your art and your market pricing.

Promotional Materials

When you have created something new and exciting in your art, take the time to make a postcard with an image of the work and place them in the gallery or galleries you are showing in. This little giveaway is what customers love to keep remembering

when they were attracted to your work. It keeps you current in their minds when they are thinking of art to buy. They may post it on their refrigerator or use it as a notecard to a friend. It tracks your art history, costs pennies and is well worth your time and effort. You could even make temporary tattoos from a special art piece you have made! Your promotional materials get you gallery ready!

CHAPTER 7
Take Your Art to the Next Level

"The artist's world is limitless. It can be found anywhere, far from where he lives or a few feet away. It is always on his doorstep."

PAUL STRAND
AMERICAN PHOTOGRAPHER

15 Creative Actions

1. Create a visual journal from an old hardcover book. Use the pages to paint or glue collections of ideas. Be bold and draw on any of the pages that have photos or writing. Mess it up and make it yours.

2. Go for a 20-minute walk; take your sketchbook and focus on drawing patterns that catch your eye. Repeat, Repeat, Repeat

3. Take your smartphone and each day at the same time take a photo in black and white. Use as a visual journal.

4. Compose weekly letters to your Muse and describe how your art making is progressing, be intimate, give your Muse a name, they are a gift from beyond.

5. Write a gratitude list for being an artist and post in your studio.

6. Reorganize your studio when you are in a fallow period of creating. It will make space for something new to emerge.

7. Use iterations from a favorite or obsessive tangle to expand a simple idea into something distinctive and unexpected. Repetition creates an unfolding continuum and a certainty simultaneously.

8. Find a dedicated figure model and practice weekly figure drawing, watch your work through subtle changes in the model and the way you express their form.

9. Experiment with your favorite art mediums; take scientific notes to find new ways to use your materials.

10. Use color in ways that are contrary to your instincts by limiting your palette, challenging your favorite colors, going for what you do not naturally like.

11. Make a sound journal in words for 21 days. Listen and document everything you hear at a specific time each day.

12. Check out your working art in a mirror upside down to see how it reads and what it needs.

13. Shoot a photo of your art in progress from your smartphone and use it as a screensaver. Keep looking at the image throughout the day, show trusted friends, see what is working and what isn't, make notes, and then make changes in the studio.

14. Create a conversation with your left and right hand between your critical voice and your creative voice.

15. Always allow time for your art to incubate before you decide its finished. Give the art time to breathe and unfold. Then come back and see if something hasn't changed, or you have changed viewing it.

As you progress through the days, weeks, months and years of your art journey, you will no doubt see your evolution in the personal framework and patterns that emerge organically through your work. In the process of contextualizing your ideas into art, your art will work you, like good medicine. Sometimes the revelations are immense, revealing "you" to you in ways only you will understand. So take notes, however brief, for sharing, or speaking about it later, or write it into a poem, because the

viewer is almost always appreciative of the artists' insights into their process of making their art.

Art Library in 12 Works (My Favorite Art Books)

"The only important thing in a book is the meaning that it has for you."

W. SOMERSET MAUGHAM,
BRITISH PLAYWRIGHT

I actually have many more books in my art library than twelve, but this is the mighty dozen! It is my intention the books listed below will inspire you to create more meaningful art. Some are quite funny, others definitively directive. They are all helpful towards growing as an artist. The wealth of insights will assist in defining your artwork and stimulate your artistic wisdom on the journey of self-expression.

- **And Then, You Act: Making Art in an Unpredictable World** by Anne Bogart

 Although this book is written by about theater, Ms. Bogart understands art making and the collaborative creative process. I loved this book and treasure its wisdom as a real gift.

- **Art and Fear** by David Bayels and Ted Orland

 If you haven't read this book yet, you must because it is a classic and belongs on every artist's bookshelf to re-read periodically. It challenges the fears most artists experience from time to time.

- **The Artists Way** by Julia Cameron

 Now a longtime classic, the wisdom is filled with artsy practices to inspire you to walk the artist's way.

- **Concerning the Spiritual in Art** by Wassily Kandinsky

 Another classic and written by a very famous painter, it belongs on the shelf of serious artists. This book became a pivot point to free art from traditional bonds and is probably more understandable today than at the time of its original publishing.

- **The Courage To Create** by Rollo May

 Another inspiring classic that paves a way into understanding how essential it is to find our fully realized self through the creative process.

- **The Creative Habit** by Twyla Tharp

 A master choreographer, Ms. Tharp has written a book about her creative habit and how to create your own, essential for becoming the artist.

- **How Painting Holds Me to the Earth** by Leigh Hyams

 Leigh Hyams was one of my mentors and always challenged us to go deeper into the uncomfortable places to create. I learned so much from her mentorship.

- **Letters to a Young Poet** by Rainer Maria Rilke

 Another classic artist book. The 10 letters speak a transcendent sincerity of purpose to a poet, applicable to any artist.

- **Sacre Bleu: A Comedy d'Art** by Christopher Moore

 This is an interesting book that is hilarious, mysterious and centers on the color Blue. I listened on Audible and enjoyed it immensely.

- **Stealing the Mona Lisa: What Stops Us From Seeing** by Darian Leader

 I found the way Mr. Leader explores the psychology of visual art amazing.

- **The War of Art** by Steven Pressfield

 Simply put, Pressfield states in no uncertain terms the importance of putting up resistance to any obstacles or barriers that keep you from creating your art.

- **Ways of Seeing** by John Berger

 Mr. Berger dives deep into how to really look at art, a must to be your own best critic and know what is working in your art.

CHAPTER 8
Final Thoughts
for You the Artist

"Paint as you like and die Happy."

HENRY MILLER
AMERICAN WRITER

B eing gallery ready implies you are creating art of lasting value and there is integrity beyond the medium and materials. The spirit of the artist has become an articulated presence within the work of art. The work is infused with something intangible and can only be felt or witnessed by the viewer. It is what the Master Painters for centuries have embodied and what we as visitors to historical collections view with awe.

You may still wonder how can your art even begin to be perceived as masterful and become gallery ready? The only answer is to create, sculpt or manipulate whatever your medium, with your full presence of being. Do the work, and pretty soon

the work will be doing you. You don't have to be a master to have embodied artwork, but you do have to have a certain ability to be in the present moment. To renew and reflect each time you are in your studio. To realize you are a vessel for the Divine and the whispers of the spirit can be found in the arts. Artists are the ones who bring the essence of beauty through their hands, minds and hearts into form, just as the Creator did with the manifestation of this planet all of the inhabitants. It is an honor and a privilege to be an artist who taps into the collective archetypes and is able to translate ideas into form through a mastery of skills.

Be the non-conformist. Move confidently with your authentic voice and visions. If you believe your art can play a role in our world, start with getting gallery ready. Think big when you are making art, but be humble when you are executing it. Don't be afraid to make mistakes because it can lead to something amazing in your art studio. Take yourself seriously, but be light enough when you are creating. Take notes every day: your inspirations, interior journeys, questions, and answers are important. Be mindful with whom you share your dreams or show your art with in the beginning stages. Play with your ideas. Think big. Think small. Merge. Expand. Be drawn to what interests you and forget about what others are doing. Get really interested in what you are doing! Find out what is calling to you and why. You may be on the verge of something so unique it can support a cause or enlighten minds. Only through being the vessel of creativity and using your authority of inner knowing, can your ideas germinate and generate. Go to the blank canvases or boulders of stone, sheets of metal, and piles of precious stones

and allow your imagination to soar as a maker of iconic beauty for our time, and I will see you at the gallery because I know you are now ready!

Artfully,

Franceska Alexander

ACKNOWLEDGMENTS

The best part of this book journey has been acknowledging the thousands of people I've had the good fortune to meet and know through and inside a beautiful gallery for over 14 years. A cup of gratitude goes to Difference Press who invited me to cross the bridge. Thank you of course, goes to every artist past, present and future, who I have the privilege of serving and who trust me with their artwork for a successful gallery experience; to the past and current staff at The Alexander Gallery, who have contributed so much with their enthusiasm and personal expertise. Thank you also goes to every one of my mentors, from Gladys Baskin onward, for seeing what was hidden within me and pushing me to go further. I'm forever grateful to my most important creative experiences, my loving sons, Matthew and Darren, who through their fierce independence, created the time for me to tend the fire of my personal dreams.

To the Morgan James Publishing team: Special thanks to David Hancock, CEO & Founder for believing in my message and me. To my Author Relations Manager, Gayle West, thanks

for making the process seamless and easy. Many more thanks to everyone else, but especially Jim Howard, Bethany Marshall, and Nickcole Watkins.

ABOUT THE AUTHOR

Franceska Alexander is a painter, gallery owner, art consultant and mentor. She was born into a family that collected, made and appreciated art. Surrounded by musicians, sculptors, photographers, actors, and designers she developed an early esthetic for fine art appreciation. From an early age she aspired to be an artist and an art instructor. In 1986 she opened her first gallery in Big Sur where she raised her two sons. Years later, she received a Masters of Fine Arts degree

in Visual Arts at the California Institute of Integral Studies in San Francisco. She owns The Alexander Gallery in Nevada City, a 14-year-old gallery representing emerging and mid-career artists. As an art gallery coach she works with artists to help them get to the next level with their art and become gallery ready. Reach her by email at Franceska.Alexander@gmail.com or her website, www.thealexandergallery.net.

THANK YOU ARTIST!

Dear Artist,

Thank you for taking the time from making art to read this blueprint of gallery ready ideas gathered together for you to get your art to the next level. I took you behind the scenes of my gallery and experience with the intention that you the visual artist may find something of value that will assist you to get gallery ready!

I would love to hear what you may have found valuable in this book, and most importantly what type of artist you are and what you have to say about your artwork, and if you have any questions about your art being gallery ready!

Please drop me an email at Franceska.Alexander@gmail.com.

You will find additional contact information at the gallery website, www.thealexandergallery.net.

With Love,

Franceska

Morgan James
Speakers Group

We connect Morgan James published authors with live and online events and audiences who will benefit from their expertise.

Morgan James makes all of our titles available
through the Library for All Charity Organization.

www.LibraryForAll.org